T0332349

PAULA MODERSOHN-BECKER

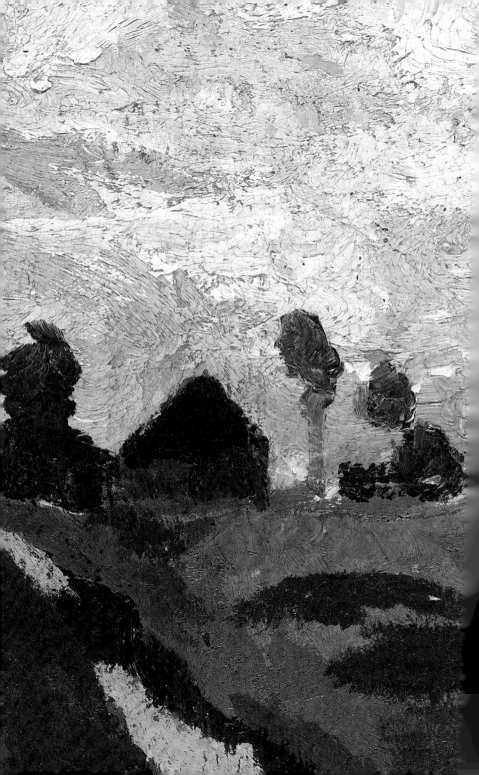

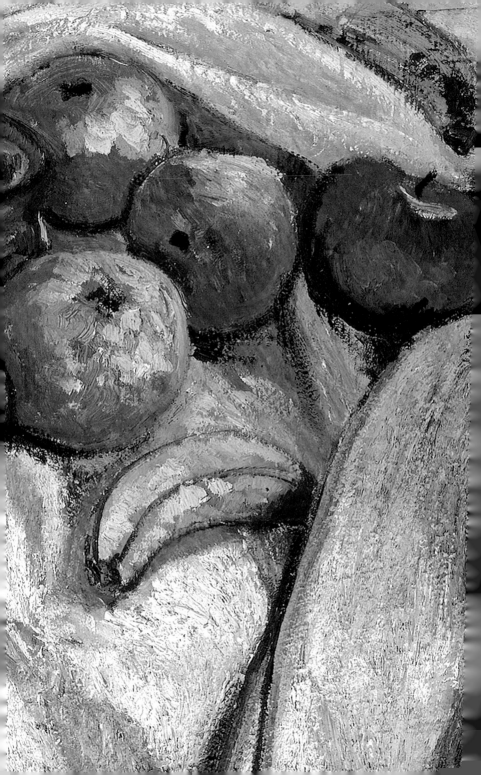

PAULA
MODERSOHN-BECKER

WITH AN ESSAY BY
Frank Laukötter

HIRMER

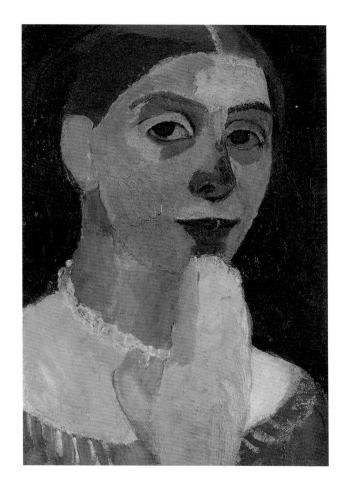

PAULA MODERSOHN-BECKER
Self-Portrait with Blue, White-Striped Dress, detail, 1906
Oiltempera on canvas, private collection

CONTENTS

"THE GREAT SIMPLICITY OF FORM, THAT'S SOMETHING WONDERFUL"[1]

Frank Laukötter

First-time viewers of Paula Modersohn-Becker's *Self-Portrait with Camellia Branch* (fig. 1) are immediately struck by the woman's huge eyes. Thanks to them the life-size portrait appears to be larger than it actually is. Modersohn-Becker magnified particular elements of the picture like the expressive eyes but neglected others—the hand holding the branch is only suggested. For her painting support she chose a simple piece of cardboard. The quantity and range of pigment is also modest, yet for all the restraint her choice of tones is delicate and exquisite. Compositional elements lend balance to the picture; strips of blue and brown on the left and right edges serve as a frame within the frame, and those verticals are repeated in the center by the line of blue above the hair, the stroke of beige marking its parting, and the green stem of the camellia branch. Paula Modersohn-Becker simplified, reduced her subjects to the essentials; she sought the minimal and monumental, made the unnoticed worthy of attention.

The artist's mother, Mathilde Becker, found this self-portrait from 1906/07 to be "ghastly." But the Hagen art collector Karl Ernst Osthaus saw in it "a distinct likeness," and bought it in 1913 for the Museum Folkwang in Hagen. The National Socialists vilified the work as "degenerate" and confiscated it in 1937. It was returned to the Museum Folkwang in 1957, after having been

1 *Self-Portrait with Camellia Branch*, 1906/07, oiltempera on cardboard
Museum Folkwang, Essen

2 *Bust Portrait of a Woman with Poppies*, ca. 1898, Oil on cardboard Museen Böttcherstraße, Paula Modersohn-Becker Museum, Bremen

exhibited at documenta I in 1955 and reproduced at the very front of the catalogue. Its standing restored, the *Self-Portrait with Camellia Branch* is now considered an icon of Classic Modernism in Germany.

Appreciation for Paula Modersohn-Becker reached a high point in 2007, the centenary of the artist's death. There were two notable exhibitions: *Paula Modersohn-Becker and Egyptian Mummy Portraits* at the Paula Modersohn-Becker Museum and *Paula Modersohn-Becker and Art in Paris around 1900 – From Cézanne to Picasso* at the Kunsthalle Bremen. The headline above a review in the *Frankfurter Allgemeine Zeitung* read "Germany's Picasso is a Woman." Quite a compliment, considering that Paula Modersohn-Becker died very young, at only 31. Then we remember that in her short life she painted more than 700 paintings but sold a mere seven; that at documenta I in 1955 she was represented with only four paintings compared to the 30 pieces by Picasso. In fact, she was one of only six women artists included, which is to say that of the 140 artists exhibited less than five percent were women. Notions of gender equality and equal rights have changed since that time, but they have not yet been fully realized.

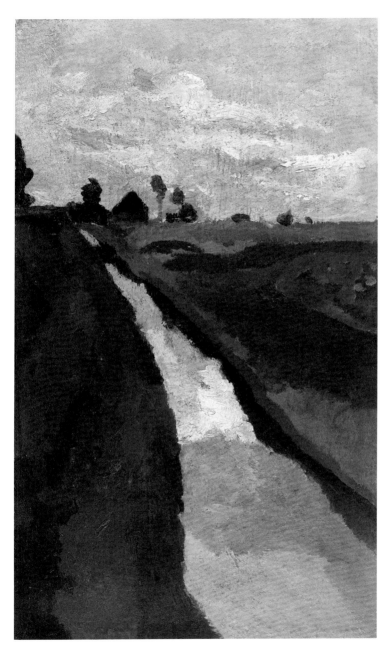

3 *Moor Canal*, ca. 1900, canvas, Kunsthalle Bremen

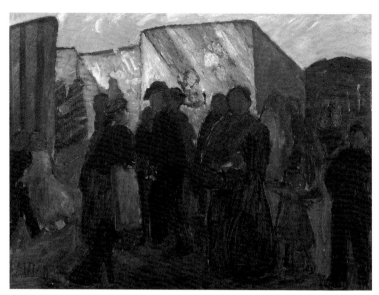

4 *Riflemen's Gathering in Worpswede I*, 1904, oiltempera on cardboard
Von der Heydt-Museum, Wuppertal

In 1892, when Paula Becker began to be interested in and practice art, the hurdles were very high. Women were no more allowed to study art like men than to vote. Her parents, Mathilde and Carl Woldemar Becker, who had six additional children, knew about the pros and cons of devoting one's time to art. Her mother liked to draw, and her father, who worked for the railroad, was a member of Bremen's Kunstverein, or Art Association. They fostered their children's artistic education, perfectly aware that an artist's calling was admirable, but that a career in art was risky, and always ended badly for a woman if she hoped to make a living from it. Carl Woldemar and Mathilde permitted their daughter to receive instruction in drawing and painting, but at the same time insisted that she acquire domestic skills and become licensed as a teacher. Paula Becker graduated from teacher's college in 1895.

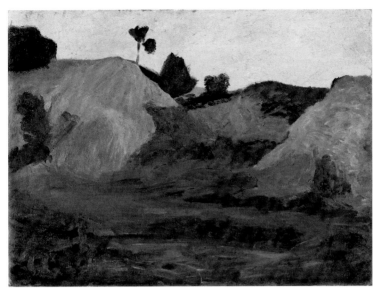

5 *Sand Pit on the Weyerberg*, 1899, oiltempera on cardboard
Bayerische Staatsgemäldesammlungen, Munich

"A WONDERLAND, A LAND OF GODS"

It was during her teacher training that she first came in contact with pictures by the Worpswede painters. In 1897 an outing after her parents' silver wedding anniversary took her to the artist colony. She determined to stay there and paint from the end of July to the end of August, for she was enchanted by the landscape: "Worpswede, Worpswede, Worpswede! 'Sunken Bell' atmosphere! Birches, birches, pines, and old meadows. Lovely brown moor, delicious brown! The canals with their black reflections, bituminous black. The Hamme with its dark sails, it's a wonderland, a land of gods."[2]

Mathilde Becker suggested that Paula study under Fritz Mackensen, and "enjoy his wonderfully sharp criticism."[3] He was a Worpswede realist painter, a gold medal winner from Munich's 1895 Crystal Palace Exhibition, and a vehement champion of nature study. In 1898 it was equally important to Paula Becker. "Force yourself," her mother wrote, "to pedantic precision in hands, eyes, and nose. When looking through your studies

6 *Moon above Fields*, ca. 1900
Oiltempera on cardboard
Paula Modersohn-Becker-Stiftung,
Bremen

recently, Mackensen spoke of a 'loveless ear.' He didn't say it in jest, but as
seriously as a judge, then he showed me that there is no such 'conventional,
loveless ear' in the whole world, that people's ears are just as distinct as
their eyes and hearts."[4] Needless to say, the teacher was able to render ears
properly. His pupil wrote in her diary that he had provided her with "a
fabulous correction."[5] This was one feature of the teacher-pupil relation-
ship; the other was related by another of Mackensen's pupils, Ottilie

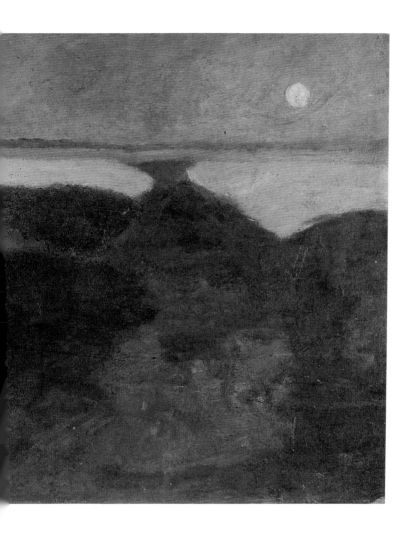

Reylaender-Böhme: "She [Paula Becker] was drawing from life, and the large nude she had started stood on the easel. Mackensen corrected it and with a penetrating gaze asked whether she had really seen what she had made in nature. Her answer was remarkable: a quick 'yes,' and then a hesitant 'no' as she looked off into the distance."[6] The switch from "yes" to "no" could be attributed to the authority of the teacher, but also—most importantly—to the change in his pupil's way of seeing, the change from the way

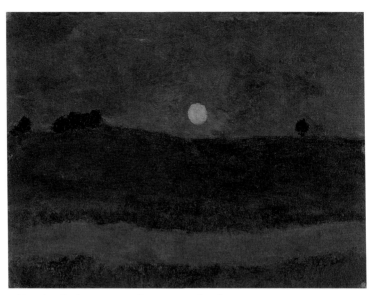

7 *Moon above Landscape*, ca. 1900, oiltempera on cardboard
Paula Modersohn-Becker-Stiftung, Bremen

she saw the model to the way she saw the picture. Becker was mostly
focused on the coherence of the picture as such, Mackensen on the model,
whether the figure had been depicted accurately—the rendering of anat-
omy as true to life as possible. It is this change in the way of seeing, this
different emphasis on how what is seen is depicted, that distinguishes
modern from pre-modern art. Mackensen tried to ignore the fact that a
picture is a thing standing for something else. Accordingly, he emphasized
the subject that had been depicted. Becker, on the other hand, made it
clear that a picture is something crafted, and focused on the representa-
tion. This is clearly visible in the series of five *Sand Pits* (fig. 5) which she
painted between 1899 and 1901, in the night pieces *Moon above Fields*
(fig. 6) and *Moon above Landscape* (fig. 7), and in *Twilight Landscape with
House and Forked Branch* (fig. 8), which, like the previous ones, was painted
around 1900. Although these pictures are small in format, their severity
and simplicity make them seem large. This is particularly true of *Twilight
Landscape with House and Forked Branch*. Two planes of color constitute
the house, which has neither doors nor windows. A simple graphic struc-

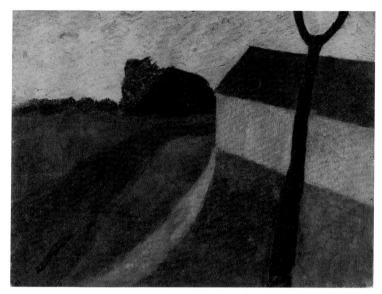

8 *Twilight Landscape with House and Forked Branch*, ca. 1900
Oiltempera on cardboard, Kunsthalle Bremen

ture represents the forked branch, which makes do without twigs or leaves. The color spectrum is as limited as the range of forms that the artist draws from. Here Becker's reduction is even more radical than that of Cézanne. It is closer to that of Cubism. The house is especially reminiscent of the Cubists, the houses Braque and Picasso would paint years later, in 1908, in L'Estaque.[7]

"... HERE THERE'S CHAMPAGNE IN THE AIR"

The idea for these paintings came not so much from Worpswede as from Paris. Between 1900 and 1907 Paula Becker, or Paula Modersohn-Becker— she married Otto Modersohn on May 25, 1901—stayed in Paris several times, a city for which she was full of praise: "It has an immense personality, this city. It provides everything to everybody."[8] And: "... Here there's champagne in the air, quite apart from the art wherever you look."[9] The inspiration Paris provided to Paula Modersohn-Becker had to do on the

9 *View from the Artist's Atelier Window in Paris*, 1900, oiltempera on cardboard
Kunsthalle Bremen

one hand with its savoir-vivre, and on the other with its abundance of art. She studied ancient art in the Louvre and newer art in the Musée du Luxembourg, attended the Académie Colarossi and visited art dealers. During her first stay in the French capital in 1900, she found pictures by Cézanne at Vollard's, which deeply impressed her. In 1907 she recalled them in a letter to Clara Rilke-Westhoff: "These days I have been thinking a lot about Cézanne, and how he is one of the three or four painters who have affected me like a storm or some major event. You remember 1900 at Vollard's. And now in the last days of my Paris sojourn really remarkable pictures from his youth at the Galerie Pellerin. Tell your husband that he should try to visit Pellerin's, he has 150 Cézannes. I saw only a small part of them, but they are glorious."[10]

These impressions were reflected in her paintings. She began to apply her colors in a flatter way, as in the above-mentioned *Sand Pits*, the night pieces and the *Twilight Landscape with House and Forked Branch*. We can only guess who the two or three other unnamed painters might have been. Presumably one was Gauguin, another Van Gogh. The former was a genius at producing a rhythmic composition in color planes, the latter a genius at placing colors stroke by stroke and giving them vitality. Modersohn-Becker borrowed from both—from the one a new flatness, from the other visible brush work. Cézanne was the mediator. His picture surface was something made up of elementary components, of "blotches" in the form of spheres, cones, and cylinders.[11] Maurice Denis was presumably the fourth source of inspiration, if not as an artist then as an art theorist: "A picture, before being a battle horse, a female nude, or some kind of anecdote, is essentially a flat surface covered with colors assembled in a certain order."[12] Denis spoke of a kind of primary pictorial alphabet, then of a kind of secondary picture text derived from that alphabet. He was the only one of the four painters named whom she came to know personally.[13] For herself Modersohn-Becker formulated his views using her own "favorite words for [painting] technique": "crisp, curly, crunchy."[14] Still-life painters might use such terms when speaking of a crust of bread they have painted, but Modersohn-Becker was not referring to what was pictured, but rather to the picture itself. What mattered to her was the facture, the factuality of the paint mediums, whether painted sour milk is first only a mush of pigment, just like the plate holding the sour milk, like the egg and the egg cup, the bread, the tablecloth, and the flowers on it (fig. 10). On the one

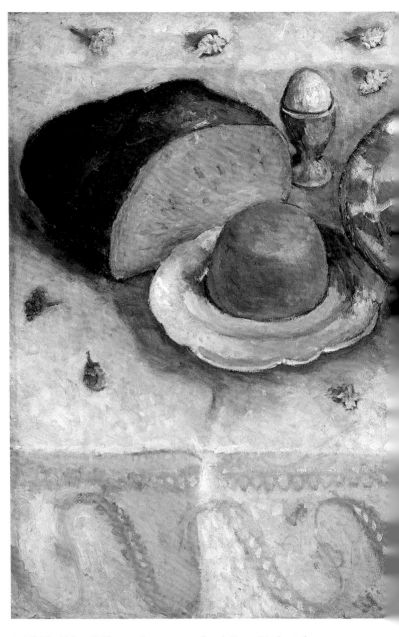

10 *Still Life with Soured Milk*, 1905, oiltempera on cardboard, Museen Böttcherstraße,
Paula Modersohn-Becker Museum, Bremen

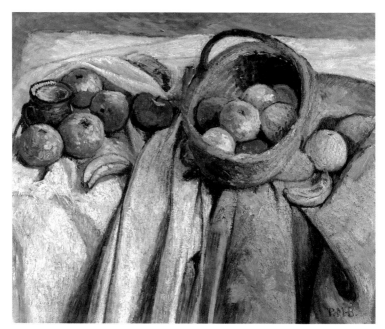

11 *Still Life with Apples and Bananas*, ca. 1905, oiltempera on canvas
Kunsthalle Bremen

hand materiality is made more uniform; and on the other it becomes clear
from this that a mush of pigment is the raw material of painting. Applying
this raw material to an even surface produces a picture, according to
Denis, and it needs to be applied to the plane surface in a specific way.
Modersohn-Becker applied her paints meaningfully and harmoniously.
For the sour milk she found a color harmony that she transferred in varia-
tions to the flowers, the bread, and the butter. Floral motifs ornament the
edge of the plate, also the table decoration, in blue and pale blue instead of
yellow and pale yellow. And with the background, or ground, she provided
stability to the bread, the butter, and the sour milk as pictorial figures: on
the one hand with the corresponding coloring of the tablecloth, which
again takes up the blue, gray, and white values of the figures, and on the
other with the folds of the cloth, which structure the picture space. Subtle
lines in black give the food and the dishes their contours, a stylistic device,
called Cloisonnism, that Modersohn-Becker adopted from the Pont-Aven

artists and the Nabis. With a minimum of painterly means and a stringent compositional strategy she achieved an enormous pictorial effect.

Gustav Pauli, the director of the Kunsthalle Bremen, was an early admirer of Modersohn-Becker's art. He exhibited her works in 1899 and 1906. The first show ended prematurely, for after a scathing newspaper review the artist removed her works from the exhibition.[15] Sobered by that fiasco, on the occasion of the second group show the director wrote a newspaper article of his own, in which he insisted that Paula Modersohn-Becker was "extremely gifted," but feared that "even now her serious and powerful talent … does not find many friends."[16] That in her dwelt "an uncommon energy," she had an "extremely refined color sense" and "a profound feeling for painting's decorative function."[17] That the influence of the "incomparable culture" of the art capital Paris, "namely Cézanne's," is "visible in her work without detriment."[18]

Paula Modersohn-Becker died in 1907. In her memory Gustav Pauli put together a one-woman show with 47 paintings and studies, including the *Still Life with Apples and Bananas* (fig. 11) that he had already shown in 1906. In 1908 he purchased it for the collection, convinced that "Paula Modersohn-Becker … will triumph, … like Liebermann, Manet, and Cézanne have triumphed."[19] This was one of the first pieces to be purchased for a public collection, before the *Still Life with Rhododendron* and the *Still Life with Haddock* were acquired in 1909 by the Städtische Galerie Elberfeld (now the Von der Heydt-Museum, Wuppertal) and in 1910 by the Städtische Galerie Hannover (now the Niedersächsisches Landesmuseum Hannover).

The first owners of art by Modersohn-Becker were Clara Rilke-Westhoff, Rainer Maria Rilke, and Heinrich Vogeler. At Christmas in 1905 Rilke bought a small painting of a child, *Infant with Hand of the Mother* (fig. 13) from around 1903, and in 1906 Vogeler purchased the *Still Life with Apples and Green Glass* from 1906. Paula Modersohn-Becker and Otto Modersohn were friends of both the Rilkes and the Vogelers. In 1902 Modersohn-Becker painted the one-year-old Marie-Luise Vogeler, called Mieke (fig. 12); in 1905 she painted a portrait of her artist colleague Clara Rilke-Westhoff (fig. 14), and in 1906 one of the poet Rainer Maria Rilke (p. 67). Whereas Rilke-Westhoff kept her portrait in her own collection between 1906 and 1918, Rilke was unhappy with his. He broke off the portrait sittings. He was a friend and collector of Modersohn-Becker, to be

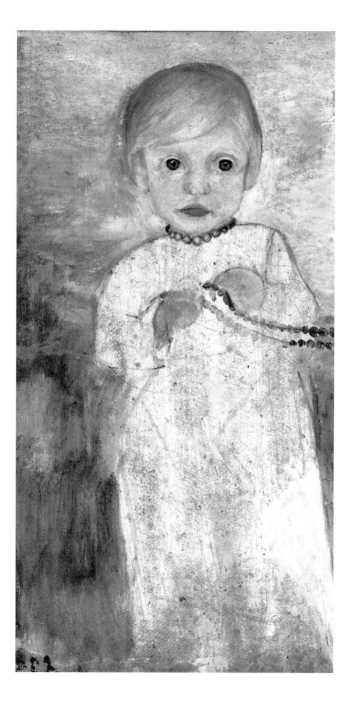

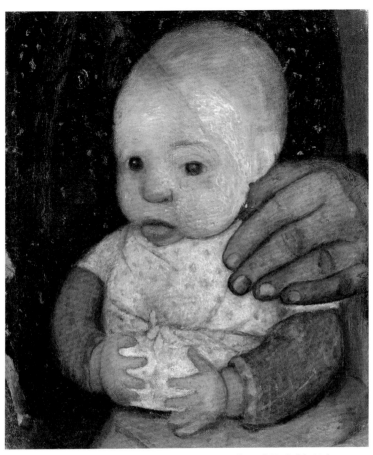

13 *Infant with Hand of the Mother*, ca. 1903
Oiltempera on canvas, Kunsthalle Bremen

12 *Mieke Vogeler with Bead Necklace*, 1902, oiltempera on cardboard
Heinrich Vogeler Sammlung im Haus im Schluh, Worpswede

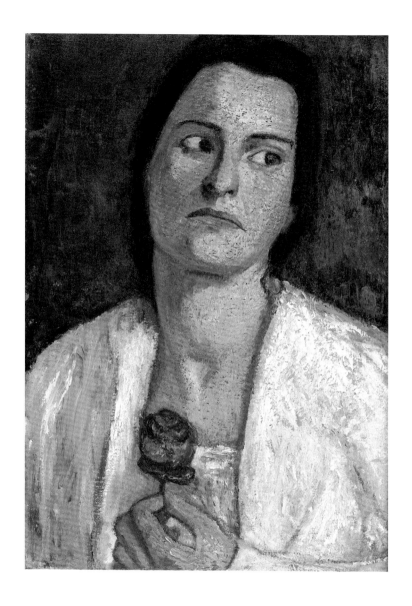

14 *The Sculptor Clara Rilke-Westhoff*, 1905, oiltempera on canvas
Hamburger Kunsthalle

sure, but the *Portrait of Rainer Maria Rilke* did not find a place either in his collection or in his essays on art. Instead, he paid homage to the artist and her self-portraits posthumously in the poem "Requiem for a Friend."

Other important friends and champions of Paula Modersohn-Becker were Helene (Lee) and Bernhard Hoetger. They had met her in Paris in 1906. In Hoetger's reminiscences of Modersohn-Becker the encounter is related as follows: on April 13, 1906, Good Friday, she knocked on the door of his atelier. He called out: "Qui est là?" She responded: "Une dame allemande." "Hours later" they arranged to get together for tea. They then saw each other "frequently," but it was only "after weeks," more precisely on May 5, 1906, that she informed him that she also painted, though not like him. He entered her atelier. "There," Hoetger recalled, "I witnessed a miracle." He encouraged her: "these are all great works, stay true to yourself, and stop taking classes." Whereupon she wrote him that he had given her a "great gift. I now even begin to believe that something will become of me. And when I think this I shed tears of bliss.—I thank you for your kind existence. You have done me so much good. I was a bit lonely / Your devoted P. M."[20]

"I AM WHO I AM, AND HOPE TO BECOME EVEN MORE SO"

Paula Modersohn-Becker was lonely, her marriage was in trouble. Rilke and his wife were aware of it. By buying the picture of a child Rilke had provided her with money for a further stay in Paris. In a letter from February 17, 1906, in which she thanked him for it, she also wrote: "I'm not Modersohn and I'm also no longer Paula Becker. I am who I am, and hope to become even more so."[21]

On February 23, 1906, a day after her husband's 41st birthday and two weeks after she herself had turned thirty, she set out for Paris—alone. Otto Modersohn wrote her several letters there urging her to return. On April 9, 1906, Paula replied: "I cannot now come back to you, I cannot. I also don't want to meet you anywhere else. By no means do I now want to have a child by you."[22]

This makes the picture she finished on May 25, 1906, all the more remarkable. It is the *Self-Portrait on 6th Wedding Anniversary* (fig. 16). In the bottom right the artist wrote in the fresh pigment: "I painted this at age 30 on my 6th wedding anniversary P. B." A first oddity: Paula Becker and Otto

15 *Two Girls in White and Blue Dresses*
1906, oiltempera on cardboard
Milwaukee Art Museum

Modersohn had married on May 25, 1901, so the 1906 anniversary was their fifth, not their sixth. A second oddity: she used the initials "P. B.," without the "M" for Modersohn, yet she signed her letters to Otto Modersohn from this time with "Your Paula Modersohn." And a third oddity: she appears to be pregnant, in her fifth or sixth month,[23] although only a month and a half earlier she had told Otto Modersohn that she had no wish to have a child by him.

How to explain these oddities, even contradictions? It may have been a simple arithmetical mistake that led Paula to record her wedding anniversary as she did, or the fact that by then the marriage had lasted too long for her, feeling like six years instead of the actual five. As a wife who had distanced herself from her husband, she was no longer "M," for "Modersohn," but "B," for "Becker." Unlike letters she addressed to her husband, she painted this picture for herself, not as she saw herself in the mirror, but the way she wished to be represented. That she pictured herself pregnant with-

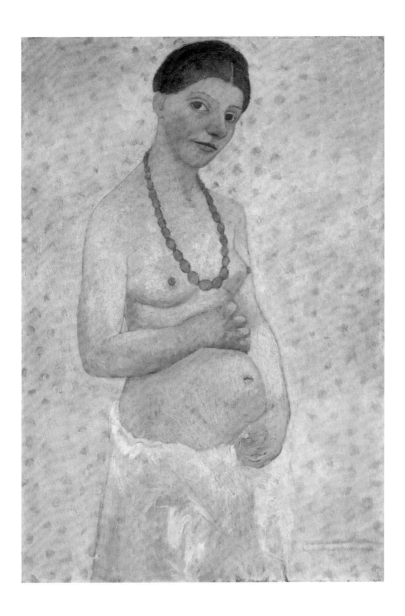

16 *Self-Portrait on 6th Wedding Anniversary*, 1906, oiltempera on cardboard
Museen Böttcherstraße, Paula Modersohn-Becker Museum, Bremen

17 *Self-Portrait, Nude with Amber Necklace, Half-Length I*, 1906, oiltempera on cardboard Private collection

out being so may be an indication that as an artist she felt within herself a creative force similar to that of an expectant mother. "I am now starting a new life," she wrote her mother only a week after Hoetger's encouragement and a good two weeks before the completion of the picture; "The last week I have lived as though intoxicated."[24]

Painting, painting as though intoxicated—by now painting was her life— she created the *Self-Portrait on 6th Wedding Anniversary*, a lasting memorial to herself and a milestone in art history: the first female nude self-portrait. She could possibly have been inspired to it by two drawings by Albrecht Dürer from the Bremen Kupferstichkabinett, for her father was a member there, her teacher Mackensen was a Dürer admirer, and the director of the Bremen Kunstverein was a champion of hers. Dürer's *Self-Portrait, Sick* from 1509/11 and *Self-Portrait Suffering, with the Features of Christ* from 1522 picture the artist nude. Just as Dürer studied himself and self-confidently approximated depictions of Christ, Modersohn-Becker courageously engaged with herself and with Dürer. She matched his male nudes with a female one—a major step. Even greater is the step

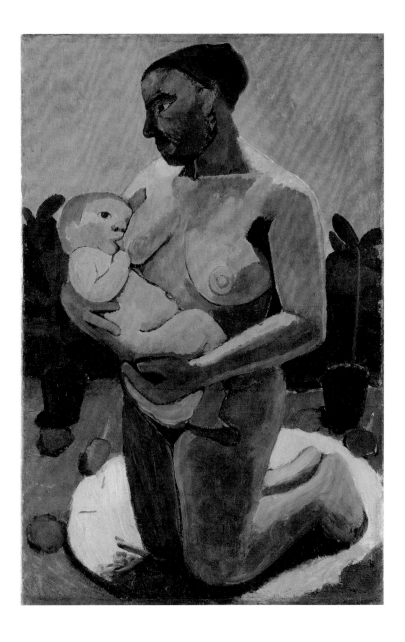

18 *Kneeling Mother with Child at Her Breast*, 1906, oiltempera on canvas
Staatliche Museen zu Berlin, Nationalgalerie

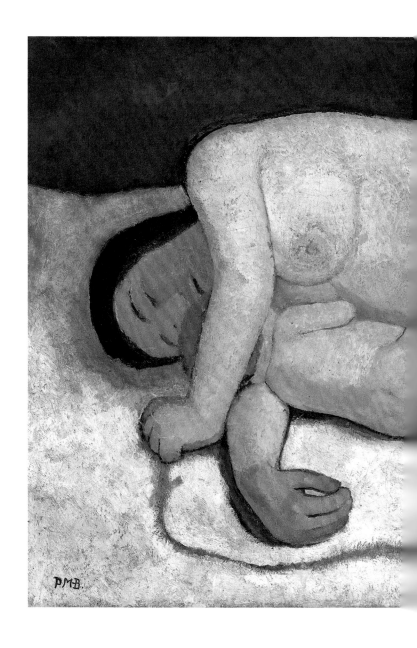

19 *Reclining Mother and Child II*, 1906, oiltempera on canvas
Museen Böttcherstraße, Paula Modersohn-Becker Museum, Bremen

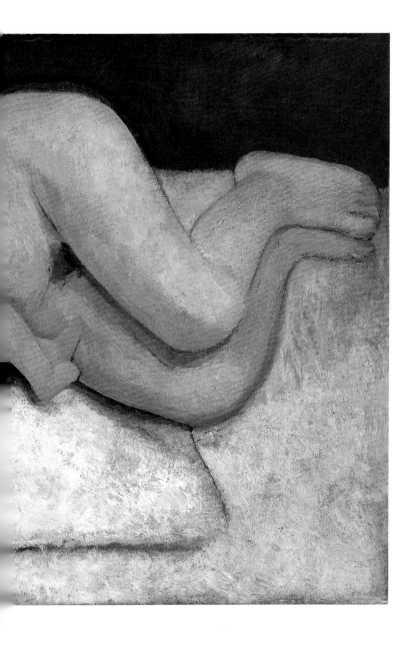

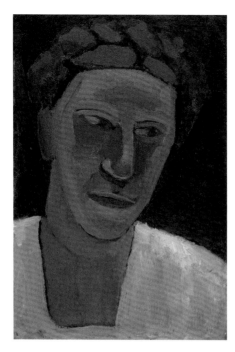

20 *Bust of Lee Hoetger*, 1906
Oiltempera on paper on cardboard
Private collection

Modersohn-Becker took in assigning herself, as Dürer had, an artistic role taken from the Bible. He had compared himself to the Son of God: he created and suffered as artist and Man of Sorrows. She took up neither a rod nor a scourge; instead, she painted a necklace and a swollen belly, cradled by her two hands. Dürer had seen his role as artist as a human Creator (*alter deus*), Modersohn-Becker hers as a generative, an expectant mother (*Maria gravida*).[25]

"I AM PAINTING ... WITH FAITH IN GOD AND IN MYSELF."

On May 21, 1906, Modersohn-Becker wrote of her painting frenzy to Martha Vogeler: "I ... am hugely enjoying my work." "I am painting lifesize nudes ... with faith in God and in myself."[26]
Along with the *Self-Portrait on 6th Wedding Anniversary*, she pictured herself as a standing nude in two self-portraits and as a semi-nude with an

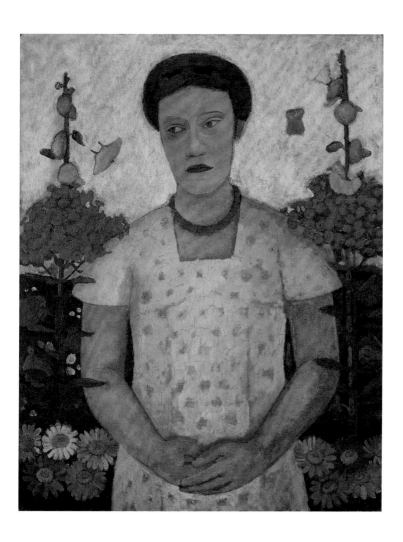

21 *Portrait of Lee Hoetger against Floral Background*, 1906, oiltempera on canvas
Museen Böttcherstraße, Paula Modersohn-Becker Museum, Bremen

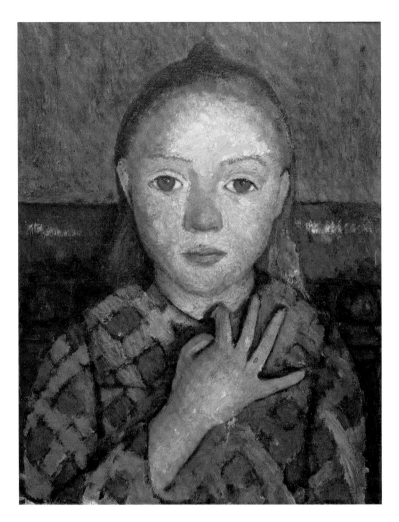

22 *Portrait of a Girl with Splayed Hand in Front of her Breast*, ca. 1905
Oiltempera on canvas, Von der Heydt-Museum, Wuppertal

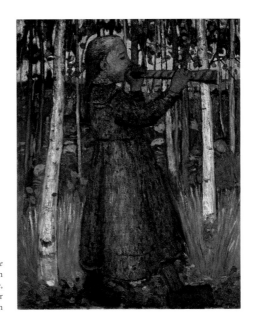

23 *Girl Playing a Flute in the Birch Forest*, 1905, oiltempera on canvas, Museen Böttcherstraße, Paula Modersohn-Becker Museum, Bremen

amber necklace in two others (fig. 17). She not only painted nudes of herself, but also of others. She produced the three large-format versions of the *Reclining Mother and Child* (fig. 19), also the *Kneeling Mother with Child at Her Breast* (fig. 18), which was even declined by Gustav Pauli when Carl Georg Heise offered it to him in 1917.

During the creative furor Hoetger had triggered, Hoetger's wife Lee served the artist as a model on several occasions. The two bust portraits of Lee Hoetger (fig. 20) seem pre-Cubist. Modersohn-Becker painted the *Portrait of Lee Hoetger Against Floral Background* (fig. 21) under the influence of works by Henri Rousseau, whom she visited in his studio along with the Hoetgers. As she wrote to Heinrich Vogeler on August 12, 1906, the portrait is "colossally full of form."[27]

On September 7, 1906, Paula apologized to Otto Modersohn for her letter of April 9: "My desire not to have a child was also altogether temporary and unfounded. … I am now sorry to have written about it. If you have not yet given up on me altogether, come soon so that we can try to reconcile."[28] They did reconcile. On November 2, 1907, Paula Modersohn-Becker gave birth to Mathilde, called Tille. The artist died on November 20, 1907. Her

24 *Child on a Red Checked Cushion*, ca. 1904, oiltempera on canvas
Museen Böttcherstrasse, Paula Modersohn-Becker Museum, Bremen

last self-portrait, the *Self-Portrait with Two Flowers in Her Raised Left Hand* (fig. 25) pictures her pregnant. Her right hand rests on her belly, as in the *Self-Portrait on 6th Wedding Anniversary*. In her left hand she is holding two flowers, one possibly a symbol of the mother-to-be, the other of the coming child.

25 *Self-Portrait with Two Flowers in Her Raised Left Hand*, 1907, oiltempera on canvas
Jointly owned by The Museum of Modern Art, New York, Gift of Debra and
Leon Black, and Neue Galerie New York, Gift of Jo Carole and Ronald S. Lauder

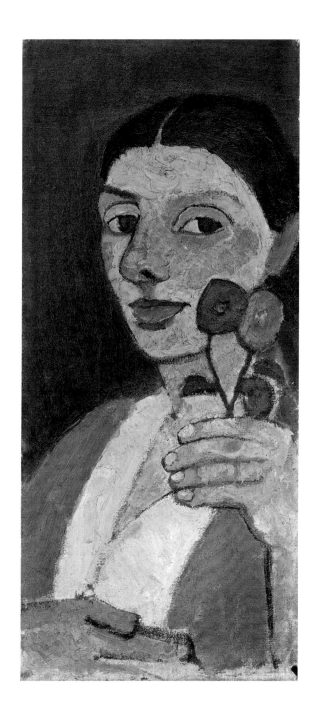

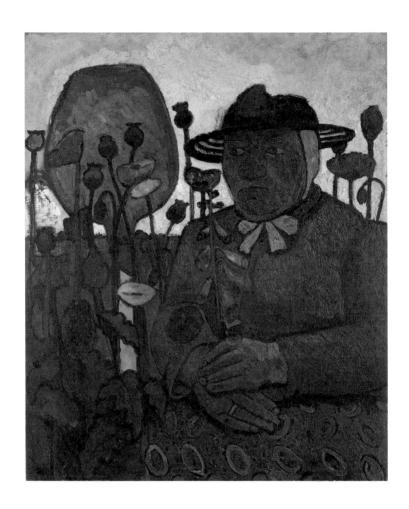

26 *Old Woman from the Poorhouse with Glass Globe and Poppies*, 1907
Oiltempera on canvas, Museen Böttcherstraße, Paula Modersohn-Becker Museum, Bremen

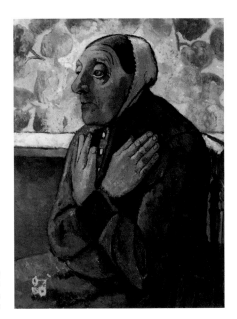

27 *Old Peasant Woman with Hands Crossed over her Breast*, 1907
Oiltempera on canvas
The Detroit Institute of Arts

"AND MY LIFE IS A CELEBRATION, A BRIEF, INTENSE CELEBRATION."[29]

When Modersohn-Becker died she was unrecognized as an artist, but her family saw to it that she became known—her husband Otto Modersohn and her daughter Tille, who established the Paula Modersohn-Becker-Stiftung in 1978. Other artists had championed their friend and colleague very early on—Heinrich Vogeler, as mentioned, and Clara Rilke-Westhoff and Rainer Maria Rilke. Museum director Gustav Pauli had exhibited the artist as a 23-year-old in 1899. He later compiled the first catalogue raisonné, first published in 1919, with second and third editions in 1922 and 1934. Between 1913 and 1934 Sophie Dorothea Gallwitz published Modersohn's letters and diaries in 14 editions, amounting to a six-figure number of copies. In 1927 Ludwig Roselius dedicated a museum to her, the world's first museum for a woman painter. Between 1950 and 1984 Günter Busch, as director of the Kunsthalle Bremen, was a Modersohn-Becker champion. Together with Wolfgang Werner, in 1998 he compiled a second

catalogue raisonné, one considered authoritative to this day. It was Busch who in 1976, on the occasion of the artist's 100th birthday, mounted a major exhibition of her work, and wrote that "for a moment in world history" Modersohn-Becker "had as though sleepwalking advanced as a trailblazer ahead of the next generation." Her "later compositions" were "key works of Modernism."[30] How modern Gustav Pauli thought her to be is clearly indicated by the fact that at the beginning of the 1920s, as director of the Hamburg Kunsthalle he hung Paula Modersohn-Becker's *Old Peasant Woman* (fig. 27) right next to Picasso's *Absinthe Drinker.*

FRANK LAUKÖTTER *was the director of the Paula Modersohn-Becker Museum in Bremen until 2014. After studying at the Kunstakademie Münster and the Westfälische Wilhelms-Universität Münster he worked for the Kunsthalle in Bremen and the Kunstsammlung Nordrhein-Westfalen. His major interests are Classic Modernism and contemporary art.*

1 Paula Becker, "Tagebuch," Paris, February 25, 1903, in: *Paula Modersohn-Becker in Briefen und Tagebüchern*, ed. Günter Busch and Liselotte von Reinken, revised and expanded edition, ed. Wolfgang Werner on behalf of the Paula Modersohn-Becker-Stiftung, Munich and elsewhere 2007, p. 410.

2 Paula Becker, "Tagebuch," Worpswede, July 24, 1897, in: ibid., pp. 122f.

3 Mathilde Becker in a letter to Paula Becker, Bremen, January 26, 1898, in: ibid., p. 140.

4 Ibid.

5 Paula Becker, "Tagebuch," Worpswede, October 18, 1897, in; ibid., p. 162.

6 Ottilie Reylaender-Böhme, [Erinnerungen an Paula Modersohn-Becker], in: *Paula Modersohn-Becker. Ein Buch der Freundschaft*, ed. Rolf Hetsche, Berlin 1932, p. 34.

7 See "Landschaften/Les cubes," in *Cézanne. Aufbruch in die Moderne*, ed. Felix A. Baumann et al., exh. cat. Museum Folkwang, Essen 2004/05, Ostfildern/Ruit 2004, pp. 142f.

8 Letter to Milly Becker, Paris, May 27, 1900, in: Modersohn-Becker 2007 (see note 1), p. 259.

9 Letter to Otto Modersohn, February 10, 1903, in: ibid., p. 394.

10 Letter to Clara Rilke-Westhoff, Worpswede, October 21, 1907, in: ibid., pp. 583f.

11 See Paul Cézanne, *Über die Kunst. Gespräche mit Gasquet. Briefe*, ed. Walter Hess, Mittenwald 1980, pp. 12, 26.

12 Maurice Denis, "L'impressionnisme et la France [1917]," in: idem, *Nouvelles théories sur l'art moderne sur l'art sacre 1914–1921*, Paris 1922, p. 66.

13 Modersohn-Becker met Denis on March 25, 1905; see Modersohn-Becker 2007 (see note 1), p. 721.

14 Otto Modersohn, [Erinnerung an Paula Modersohn-Becker], in: Hetsch 1932 (see note 6), p. 26.

15 See Wulf Herzogenrath, "Paula Modersohn-Becker und Gustav Pauli. Der Kampf um Paula Modersohn-Becker als Vorspann zum 'Protest deutscher Künstler' 1911, in: *Paula Modersohn-Becker 1876–1907. Eine Retrospektive*, ed. Helmuth Friedel, exh. cat. Lenbachhaus, Munich 1997, pp. 47–49.

16 G[ustav] P[auli], "Zweierlei Kunst," *Bremer Nachrichten*, vol. 164, no. 311, Sunday, November 11, 1906, p. 2, quoted in *Paula Modersohn-Becker 1876–1907 – Werkverzeichnis der Gemälde*, ed. Günter Busch and Wolfgang Werner, Munich 1998, vol. 1, p. 43.

17 Ibid.

18 Ibid.

19 G[ustav] P[auli], "Zweierlei Kunst," *Bremer Nachrichten* vol. 166, no. 345, Sunday, December 13, 1908, p. 7, quoted in *Paula Modersohn-Becker und die Kunst in Paris um 1900 – Von Cézanne bis Picasso*, ed. Anne Buschhoff and Wulf Herzogenrath, exh. cat. Kunsthalle Bremen 2007/08, Munich 2007, p. 275.

20 Letter to Bernhard Hoetger, May 5, 1906, in: Modersohn-Becker 2007 (see note 1), p. 533.

21 Letter to Rainer Maria Rilke, Worpswede, February 17, 1906, in: ibid. p. 520.

22 Letter to Otto Modersohn, Paris, 14 Avenue du Maine, April 9, 1906, in: ibid., p. 528.

23 I am grateful to Professor Marin Langer, chief physician at the Universitäts-Frauenklinik Währinger Gürtel 18–20, Vienna, for this assessment by e-mail on October 12, 2012.

24 Letter to her mother, Mathilde Becker, Paris, May 10, 1906, in: Modersohn-Becker 2007 (see note 1), p. 539.

25 See Ernst Kris and Otto Kurz, *Die Legende vom Künstler. Ein geschichtlicher Versuch*, Frankfurt am Main 1995, pp. 84–86.

26 Letter to Martha Vogeler, Paris, May 21, 1906, in: Modersohn-Becker 2007 (see note 1), p. 542.

27 Letter to Heinrich Vogeler, Paris, August 12, 1906, in: ibid., p. 555.

28 Letter to Otto Modersohn, Paris, September 7, 1906, in: ibid., p. 542.

29 Paula Becker, "Tagebuch," Worpswede, July 26, 1900, in: ibid., p. 266.

30 Günter Busch, "Paula Modersohn-Becker und die Malerei ihrer Zeit," in: *Europäische Hefte: ein Kulturspiegel, Cahier européens. Notes from Europe* 3, no. 4 (1976), p. 74.

BIOGRAPHY

Paula Modersohn-Becker
1876–1907

1876 Paula Becker is born in Dresden on February 8, the third of the seven children of Carl Woldemar and Mathilde Becker (née von Bültzingslöwen). Her father works as a construction and operations inspector for the Berlin-Dresden Railway.

1886 While playing in a sand pit Paula Becker is buried together with her cousins Cora and Maidli Parizot. Cora is killed in the accident.

1888 Her father is transferred to Bremen as a construction advisor for the Prussian Railway Administration and the family moves to Bremen, Schwachhauser Chaussee 29. Paula attends the private girls' school run by Ida Janson. The family is very active culturally; artists like Heinrich Vogeler are counted among their circle of friends, as is Gustav Pauli, director of the Kunsthalle Bremen.

1892 Hoping to learn English and housekeeping, Paula spends roughly nine months at the country house of her aunt Marie Hill, her father's half-sister, near London. After she takes first private drawing lessons, Paula's uncle Charles Hill arranges for her to attend the drawing classes taught by Mr. Ward at London's St. John's Wood Art School.

1893–95 Reluctantly, but following her father's wishes, Paula attends the teachers' college in Bremen, and passes her final examination on September 18, 1895. At the same time she receives instruction in drawing and painting from the Bremen painter Bernhard Wiegand. The Kunsthalle Bremen's first group exhibition by the Worpswede painters introduces her to the works of Fritz Mackensen, Otto Modersohn, and Heinrich Vogeler.

1896 In April and May Paula Becker participates in a six-week course given by the respected drawing and painting school of the Berlin Union of Women Artists and Friends of Art. In October she begins six months of training there. Since Paula's father retires prematurely following the closure of the Bremen railway office, the family finds itself in straitened circumstances. Her stay in Berlin is made possible by her uncle, Wulf von Bültzingslöwen, whose house she stays in, and by her mother, who is able to cover the cost of painting lessons by taking in a boarder.

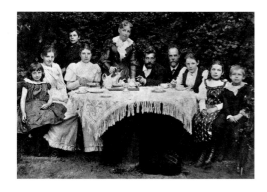

28 The Becker family in the garden of the Schwachhauser Chaussee house, Paula 2nd from left, her parents in the middle, 1893

29 Paula Becker, ca. 1895

1897 In February she joins the class of the painter Jeanne Bauck, under whose influence she paints mainly portraits. A June outing on the occasion of her parents' silver anniversary takes Paula Becker to nearby Worpswede. Inspired by the artist colony, she determines to stay in Worpswede from the end of July to the end of August and paint there. Along with Fritz Mackensen, the colony's founder, she makes the acquaintance of Otto Modersohn, whose landscape pictures she admires.

1898 An unexpected inheritance and financial support from relatives allow Paula Becker to continue her studies in Berlin. After their completion, she moves to Worpswede on September 7. Together with the sculptor Clara Westhoff—later wife of Rainer Maria Rilke—Marie Bock, and Ottilie Reylaender, she paints under the supervision of Fritz Mackensen.

1899 In December Paula exhibits her work together with her artist friends Marie Bock and Clara Westhoff at the Kunsthalle Bremen. After a dismissive review in the *Weser-Zeitung* by the art critic Arthur Fitger, Paula promptly withdraws her pictures and on New Year's Eve sets out for Paris.

1900 Paula paints in the life class at the private Académie Colarossi and receives additional instruction in anatomy at the École des Beaux-Arts. At the gallerist Ambroise Vollard's she discovers pictures by Paul Cézanne, which leave a lasting impression. She comes in contact with other artists, and becomes acquainted with Emil Nolde and others. In June several of the Worpswede artists, including Otto Modersohn, arrive in Paris and with her visit the World's Fair. While they are there, on June 14 Modersohn's ailing wife Helene dies in Worpswede. The party returns there, and weeks later Paula Becker follows. She sets up a studio at the home of Hermann Brünjes in Ostendorf.
Together with Otto Modersohn, Clara Westhoff, and her sisters Milly and Herma, Paula becomes a member of the close circle of friends around Heinrich Vogeler and his later wife Martha Schröder, which regularly meets at Vogeler's "Barkenhof" (Low German for "Birkenhof," or "Birch Tree Cottage"). The poets Carl Hauptmann and Rainer Maria Rilke visit Worpswede and are introduced into the circle of friends. On September 12 Paula Becker and Otto Modersohn become engaged.

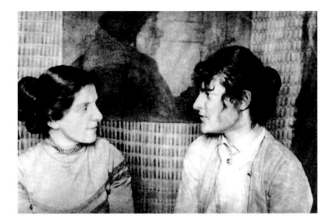

30 Paula Becker and Clara Westhoff in her first Worpswede studio, ca. 1899

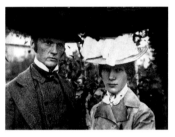

31 Heinrich and Martha Vogeler, ca. 1901

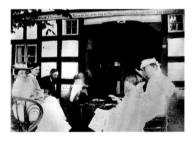

32 In front of Vogeler's "Barkenhof"; on the facing beam the house blessing written by Rilke. From left to right Herma Becker, Philine Vogeler, Otto Modersohn, Heinrich Vogeler, Martha Vogeler, Elsbeth Modersohn, Paula Modersohn-Becker, ca. 1904

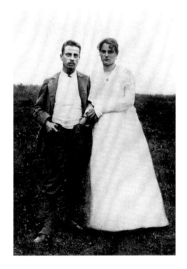

33 Rainer Maria Rilke and Clara Westhoff, 1901

1901 Early in the year Paula completes a cooking course in Berlin at her parents' request. There she frequently meets with Rilke, who is living in Schmargendorf. On May 25 Paula Becker and Otto Modersohn are married; he brings his three-year-old daughter Elsbeth into the marriage. Paula Modersohn-Becker keeps her atelier at Brünjes's, in which she works about eight hours a day. Her father, Carl Woldemar Becker, dies on November 30.

1902 In her diary Modersohn-Becker expresses her disappointment over her marriage with Otto. She focuses intensely on her painting, and begins deliberations regarding color and picture structure.

1903 From the beginning of February to the middle of March she stays in Paris again, taking life drawing classes at the Académie Colarossi. Through Rilke, who is staying in Paris with his wife at the time, she visits Auguste Rodin in his atelier. She produces mainly portraits of children, mother and child pictures, and still lifes. Modersohn takes a critical view of the simplification of form in his wife's art.

1904 Modersohn-Becker largely withdraws from her painter colleagues in Worpswede. In her search for new picture forms and subjects she produces preliminary studies for such paintings as *Girl Playing a Flute in the Birch Forest* (fig. 23). In the winter she works very little, and at Christmastime relates in a letter to her sister Herma that she is open to outside inspiration.

1905 During her third visit to Paris she enrolls in a life painting class for a month at the Académie Julian, starting on February 14. Together with her sister Herma, who is studying French in Paris, she enjoys Parisian nightlife and attends dance performances and revues. Modersohn, her sister Milly, and Vogeler and his wife join her in Paris at the end of March. Together they visit Gustave Fayet's Gauguin collection. In April they return to Worpswede. There she becomes acquainted with the artist Maria Franck, the later wife of Franz Marc, who spends the summer and fall in the artists' colony in order to paint under the supervision of Otto Modersohn.

34 Paula and Otto Modersohn in
his studio in the old village school, 1901

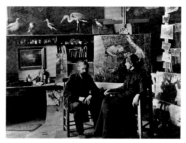

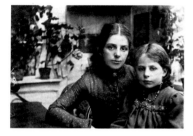

35 Paula Modersohn-Becker and
Elsbeth Modersohn, ca. 1903

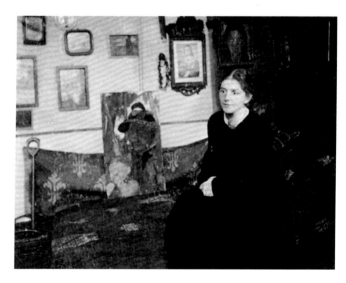

36 Paula Modersohn-Becker in
her studio at Brünjes's, ca. 1905

37 Paula and Otto Modersohn's
Worpswede house, ca. 1902

1906 In mid February she confesses to Rilke that she wants to leave her husband. By buying her painting *Infant with Hand of the Mother* (fig. 13) the year before, Rilke had given her the financial means to leave Worpswede. On February 23, a day after Otto's birthday, she sets out on a fourth trip to Paris. Despite the separation, she continues to receive financial support from her husband. Once again she takes part in an anatomy and life course as well as art history lectures at the École des Beaux-Arts. In Paris she makes the acquaintance of the painter and sculptor Bernhard Hoetger and his wife Helene (Lee). Hoetger is enthusiastic about her art and encourages her in her work. With the painting *Self-Portrait at 6th Wedding Anniversary* (fig. 16) Modersohn-Becker paints the first female nude self-portrait in art history. In September she decides to return to her husband, who visits her in Paris through the winter. At the Kunsthalle Bremen Modersohn-Becker is represented with four pictures in a November exhibition of Worpswede artists. Both Gustav Pauli, director of the Kunsthalle Bremen, and the *Bremer Courier* review her works positively.

1907 The couple return to Worpswede together at the end of March. During the summer there she paints figural pictures, including the *Old Woman from the Poorhouse with Glass Globe and Poppies* (fig. 26). On November 20, only a few days after giving birth to her daughter Mathilde on November 2, Paula Modersohn-Becker dies from an embolism in Worpswede.

38 Otto Modersohn sketching
on the Weyerberg, ca. 1903

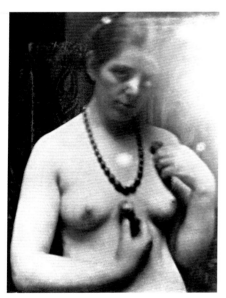

39 Paula Modersohn-Becker in her
Paris atelier, presumably taken by
her sister Herma for the composition
of the *Self-Portrait as Semi-Nude with
Amber Necklace*, 1906

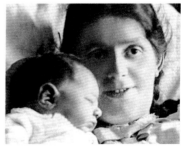

40 Paula Modersohn-Becker with her
daughter Mathilde, November 1907

Self-Portrait with Right Hand on Chin, 1906, monotype on newsprint,
Paula Modersohn-Becker-Stiftung, Bremen

ARCHIVE

Occasional Texts, Letters, Documents
1898–1920

1

In May 1898, Carl Woldemar Becker wrote his daughter Paula at the end of her training in Berlin: "You will be delighted to hear that Mackensen has offered to support you with advice in your painting classes during your vacation time." At the time he did not yet know that she was planning a longer sojourn in Worpswede, not just a "vacation." Fritz Mackensen had discovered the little village in the Teufelsmoor for his painting as early as 1884 and was one of the founders of the artist colony in 1889. At that time he was already a successful artist distinguished by a number of prizes, and was someone from whose "criticism" Paula Becker hoped to gain a great deal. On October 18, 1898, she wrote in her diary:

"Today a huge window was cut into my wall. Now it is light in my green blue room. Little by little everything is being arranged. What was new and exciting is becoming a comforting habit, and I am filled with a quiet peace. This, I believe, is the spirit in which I can work and learn. Mackensen comes by every few days and gives me wonderful critiques. It does me good to be around him. There is such a fire burning in him for his art. When he talks about it his voice takes on a warm, vibrant tone so that I too begin to tremble. When he quotes Dürer it is with the solemnity in his voice and gestures of a pious child reciting his Bible verses. His god is Rembrandt."

2

Paula Modersohn-Becker saw her second stay in Paris in 1903 as a chance to "examine Worpswede from here through critical lenses." Although it is clear that by this time a certain disenchantment had entered into her marriage, the letters she wrote her husband during her month and a half in Paris attest to a warm-hearted interest in the welfare of those left at home. Her critical eye was directed more toward her further artistic development and setting herself apart from the other Worpswede painters. She excitedly absorbed the many inspirations in Paris, and after encountering Chinese and Japanese art determined: "It strikes me that our art is far too conventional."

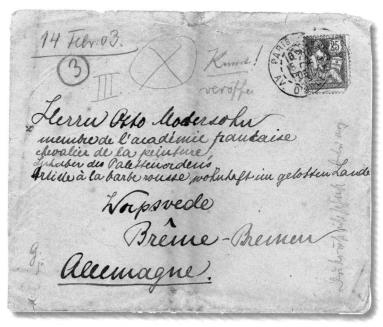

Paris, Boulevard Raspail 203, February 14, 1903

Dear Otto,

 I am now starting my third letter to you and also beginning to passion-
ately await a first one from you. And this morning I comforted myself with
the fact that it was Sunday. Dear boy, what might you be doing, and how
might you be, and what might you be painting? . . . I'm happy that little by
little I am able to think in this hubbub, which was impossible for me until
today. All in all I've been carrying around a miserable, godforsaken feel-
ing. I already feel that if I want to learn something this time I shall have to
work harder than the first time. At that time I didn't yet have you and had
no home. But I feel that it is very good for once to consider everything
from a distance. You don't come out badly. Sometimes I feel like crying in

2 Envelope from a letter from Paula Modersohn-Becker to her husband,
Paris, February 14, 1903, Paula Modersohn-Becker-Stiftung, Bremen

all the street noise. Today I desperately looked for a little room with a view of a tree, as yet without success. Apartments aren't expensive. My present one costs 39 francs a month, roughly 30 marks. But a clanging electric streetcar swishes past and disturbs my so necessary sleep. . . . In the afternoons I do life drawing at the Academy. Every half hour a different pose. I am enjoying it a lot. . . . Here people everywhere assume I am still unmarried. But I devoutly wear my wedding ring, and when I don't wear it I freeze. – What does Elsbeth have to say about her traveling mother? Does she ever speak of me? You have to report everything to me. And go to Brünjes's sometime, and tell me how things are there. Also make sure that the mice aren't eating my art. Give little Frau Vogeler my best. I kiss you tenderly.

<div style="text-align:right">Your little nomadic wife</div>

I also saw a wonderful little marble woman by Rodin. And Mackensen? I don't like the hotel food at all, and would love to have Bertha here so she could cook me something nice. – Let Herma cut your hair, not that cynical barber.

3

Paula Modersohn-Beccker received little appreciation for her art during her lifetime. One of the few to recognize her talent early on was her husband Otto Modersohn, who in 1902 noted: "All are quietly in agreement: Paula won't amount to anything" and "No one knows her, no one values her – that will change." The sculptor Bernhard Hoetger, whom the painter met in Paris in 1906, could also later claim to have been one of the artist's "discoverers." Paula Modersohn-Becker wrote to her husband from Paris on April 25, 1906: "Before my trip [to Brittany] I called on your countryman, the sculptor Hoetger, whose works made such an impression on me in Bremen." Just how much Hoetger's positive response to her work and encouragement elated her is apparent from the lines she wrote to the artist a few days later.

Paris, May 5 [1906]

Dear Mr. Hoetger,

That you have faith in me is to me the most precious faith in the whole world, because I believe in you. What good is the faith of the others if I don't believe in them? You have given me the most wonderful thing. You have given me myself. I have been given courage. My courage always stood behind barricaded gates, and couldn't go in or out. You have opened those gates. You have given me a great gift. I now even begin to believe that something will become of me. And when I think this I shed tears of bliss. – I thank you for your kind existence. You have done me so much good. I was a bit lonely

Your devoted P. M.

Your sister-in-law is very beautiful

4

Bernhard Hoetger described his memories of his first encounter with Paula Modersohn-Becker on April 13 in the volume Junge Kunst, Paula Modersohn, *first published by Klinkhardt & Biermann Verlag in 1920.*

After her death Hoetger designed not only a monumental tombstone for her—which found little favor with Otto Modersohn—but also the Paula Modersohn-Becker Museum in Bremen. As the first museum in the world devoted to a modern woman artist, it was dedicated on Böttcherstrasse on June 2, 1927, by the collector and patron Ludwig Roselius.

4 "Memories of Paula Modersohn by Bernhard Hoetger," facsimile from *Junge Kunst*, Leipzig 1920, pp. 12–15, Archiv Klinkhardt & Biermann Verlag

Erinnerungen an Paula Modersohn
von Bernhard Hoetger.

Sie war ein Mensch, der in eigener Verantwortung das Leben liebte und ausbaute, keine Situationen benutzte, um Vorteile zu erreichen.

Ich denke immer noch an unsere erste Begegnung in Paris Es klopfte an mein Atelier. Ich aber war damals kampfmüde mit lahmen Flügeln und liebte keine Besuche, aber die eigenartige Antwort auf mein „qui est là" „une dame allemande", machte mich neugierig. Nachdem ich die sich entfernenden Schritte messend, die Tür vorsichtig geöffnet, sehe ich einen zierlichen Menschen mit graziös wiegenden Schritten sich entfernen. Ich fühle die Anmut dieses jungen Weibes und das Verlangen, sie näher zu sehen. Meine Frau rief ihr nach und einige Stunden später trank sie mit uns Tee. Sie erzählte. Ihre Äußerungen hatten Reife. Alles schien erlebt.

Was von ihr kam an Erlebtem, war äußerlich als Wortbild verschickt, aber glühend, freudig, selbstvertrauend und — bescheiden. Wir sahen uns dann oft. Ich wußte jetzt, sie war die Frau des Malers Otto Modersohn aus Worpswede. Sie machte aber keinen Gebrauch von der Tatsache, sondern verzichtete gern auf die bequemere Einführung. Ihre Worte lösten immer mehr eine erwartende Spannung in mir

aus. Sie dachte einfach und tief; es war Reichtum und Eigenart, was sie gab.

Nach Wochen regen Gedankenaustausches entschlüpfte ihr einmal das Wort: „Ja, das hätte ich bestimmt anders gemalt." „Was, Sie malen?" und dann ein bescheidenes „ja". Ich stand auf und drängte neugierig zum ersten Male in ihr Atelier. Dort erlebte ich still und ergriffen ein Wunder. Sie hing an meinen Lippen. Ich konnte ihr nur sagen „es sind alles große Werke, bleiben Sie sich selbst und geben Sie den Besuch der Schule auf". Der war ihr geraten worden, weil man in Worpswede immer noch glaubte, sie müsse zeichnen lernen. Sie war glücklich erlöst und schrieb mir am folgenden Tage einen rührenden Brief. Wir wurden immer mehr gute Freunde. Unser Schaffen wurde frisch und freudiger, wir fühlten gegenseitig das beschauende Auge des andern als einen tiefen Genuß, Bestätigung und Kraft. Wir arbeiteten und sahen uns viel aus Bedürfnis, oft schon am Morgen. Wir tranken dann den Morgenkaffee gemeinsam. Sie hatte schon Arme voll Blumen und Früchte vom Markt geholt. In ihr lebte die erfrischendste Natur. Sie liebte Glanz und Freude, war bescheiden, hatte einen wundervollen weiblichen Sinn, der Tat wurde, wenn liebe Freunde zu ihr kamen. Meiner Frau war sie eine gute Freundin geworden. Wir ebten einige Tage in Burs bei Paris, wo sie uns besuchte. Wir pflückten Blumen für Stilleben, wir sahen den Sommer, hörten die summenden Hummeln. Sie hob oft die Hand und tauchte sie mit den Blumen in das Blau des Himmels, dann lächelte sie. Die Hand und ihre Empfindungen wurden dann bewegter. „Gegen die Luft auf dem Moorgraben, die Bauern, Birken, Mütter, Brüste, Leiber, Kinder, merkwürdig, die

4

Memories of Paula Modersohn
by Bernhard Hoetger

She was a person who loved and structured life in a responsible manner, never exploiting situations to gain advantage.

I still recall our first encounter in Paris. There was a knock on the door of my studio. At the time I was battle-weary and discouraged, and not looking forward to visitors, but when I asked "qui est là" the odd response "une dame allemande" aroused my curiosity. After I had crossed the floor and cautiously opened the door, I saw a delicate person walking away with graceful, swaying steps. I felt the charm of this young woman and a desire to see her more closely. My wife called after her, and a few hours later she

schwere Hand auf dem Fleisch, die Menschen und die Erde
——— erst muß ich dieses alles tun, dann aber werde ich
das tun, was ich muß." Sie dachte an Monumentalmalerei,
an befreiende Kompositionen.

Die Zeiten flossen dahin und wir schafften. Sie feierte oft
ganz für sich. Sie hatte innere Feste, die sie auch in beson-
derer Form beging. Sie saß allein strahlend in ihrem Atelier
vor gut gedecktem Tisch mit schönen Blumen im Haar. Sie
brauchte solche Dinge, wie sie oft sagte, um das Leben voll
zu leben. Worpswede war für sie kraftspendend, „wenn
der Frühling kommt, dann muß ich am Moorgraben sitzen,
der Abend ist schön, wenn die Dinge aus sich leuchten".
Mutter wollte sie werden. Den früheren Einfluß von ihren
Freunden in Worpswede hatte sie überwunden, sie liebte
diese Menschen noch, aber ihr Leben, ihre Tat selbst war
einsam und blieb einsam. Sie hatte diese schaffenden Freunde
hinter sich gelassen mit einem bedauernden Lächeln, aber
sie war innerlich selig in ihrer Arbeit. Oft kam sie gelaufen
und rief: „Wissen Sie, eine gute Tat setzt sich doch durch
und einmal werde ich es doch kriegen, glauben Sie, Hoetger,
ich kriege es bestimmt."

Sie wollte Mutter werden. Sie kam mit dem Kinde unter
dem Herzen zu uns nach Büren in Westfalen. Sie wollte uns,
bevor sie gebar, noch einmal sehen. Dann wurde sie Mutter
und ihre Lebensflamme ertrank im ewigen Meer, indem sie
ein anderes Licht anzündete.

Wir waren erschüttert, kamen einige Monate später, um
ihre gesamten Werke zu ordnen und für Ausstellungen vor-
zubereiten. Ich erlebte wiederum ein Wunder. Ich war
wiederum erschüttert. Ihr Atelier war klein, aber die Kraft
14

drank tea with us. She spoke of herself. What she said was very mature. Everything seemed to have been experienced directly.

What she related of her past was awkward as a narrative, but fervent, joyous, self-confident, and—humble. We then saw each other frequently. I now knew that she was the wife of the painter Otto Modersohn from Worpswede. But she did not take advantage of the fact, preferring not to use his name to smooth her way. Her words increasingly produced an expectant interest in me. Her thinking was direct and profound; there was a richness and uniqueness in everything she said.

After weeks of brisk exchanges, she once happened to say: "Yes, I certainly would have painted that differently." "What, you mean you paint?" Then a modest "yes." Curious, I stood up, and for the first time made my way into her studio. There I was speechless and moved, for I witnessed a miracle.

und die Lebensflamme rissen alles Leben mit sich und man
jubelte in dieser Welt.

„Ich liebe, gewisse Dinge für mich zu leben, als kleine
Geheimnisse." Ich fand solche kleinen Geheimnisse, merk-
würdige Schatullen, einen feinen Stoff, Ketten, ganz kleine
Winkel mit einer Konsole, auf der, nur für ihr Auge bestimmt,
ein winziges Etwas aufgebaut war, ein Tontorso von mir
aus Paris mit abgebrochenem Kopf und Armen, mit Ketten
umhängt.

Ihre letzten Arbeiten sagten mir es fest und überzeugend,
daß sie noch einen weiten Weg gehen wollte. Ich dachte
an ihre Worte: „Hoetger, ich kriege es doch."

She waited for what I might say. I could only tell her: "these are all great
works, stay true to yourself, and stop taking classes." She had been advised
to do so, for in Worpswede it was still believed that she needed to learn to
draw. She was greatly relieved, and on the following day wrote me a touch-
ing letter. We became increasingly good friends. Our work became fresh
and more joyful, each perceived the other's observant eye as a profound
pleasure, confirmation, and strength. We worked and needed to see each
other a great deal, often even in the morning. We would drink our morning
coffee together. She would have already bought armloads of flowers and
fruit at the market. There was something most refreshing about her. She
loved radiance and joy, was humble, had a wonderfully feminine apprecia-
tion, which was clear when good friends visited her. She had become a
good friend of my wife's. We stayed for a few days in Burs, near Paris,

where she visited us. We picked flowers for still lifes, we relished the summer, listened to the buzzing bumblebees. She would often raise her hand with the flowers and thrust it into the blue of the sky, then smile. Her hand and her feelings would then grow more agitated. "Against the air on the Moorgraben, the peasants, birches, mothers, breasts, bodies, children, remarkable, the heavy hand on the flesh, the people and the earth—I first have to do all this, but then I will do what I must." She thought of monumental painting, of liberating compositions.

Time passed, and we worked. She often celebrated all by herself. She had inner celebrations she would commemorate in a special way. She would sit radiantly alone in her atelier at a well-set table, with lovely flowers in her hair. She needed such things, as she often said, in order to live life fully. Worpswede was invigorating for her, "when spring comes I have to sit on the Moorgraben, evening is beautiful, when things take on a glow of their own." She wanted to become a mother. She had transcended the earlier influence of her friends in Worpswede; she still loved these people, but her life and her work itself was solitary, and remained solitary. She had left these creative friends behind with a regretful smile, but inside she was blissful in her work. She would frequently run to me and exclaim: "You know, a good deed makes its way after all, and sometime I am going to make it, believe me, Hoetger, I'm definitely going to make it."

She wanted to become a mother. She came to us in Büren in Westphalia while she was pregnant. She wanted to see us once again before giving birth. Then she became a mother, and her life flame drowned in the eternal sea as she ignited another light.

We were shattered, came a few months later to organize and prepare all her work for exhibitions. Again I witnessed a miracle. I was awestruck once again. Her atelier was small, but the strength and the life flame tore all life with it, and one rejoiced in this world.

"I love living certain things by myself, as little secrets." I found such little secrets, remarkable treasure chests, an elegant fabric, necklaces, very tiny corners with a console, on which, intended for her eyes only, a tiny something was set up, a clay torso of mine from Paris with the head and arms broken off and hung with necklaces.

Her last works told me distinctly and convincingly that she still intended to go a long way. I thought of her words: "Hoetger, I'm going to make it."

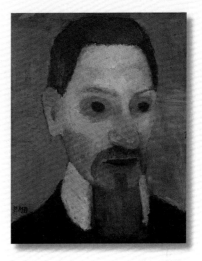

5 a

5

Paula Modersohn-Becker met Rainer Maria Rilke during one of the Sunday gatherings of artist friends at the Barkenhof. On September 3, 1900, she recorded her first impression of the poet in her diary: "Also Rainer Maria Rilke, a keen lyrical talent, delicate and sensitive, with small, touching hands. He read us poems, tender and full of portent. Sweet and wan." From this first encounter a lifelong friendship would develop. She not only carried on intense exchanges with him about art concepts and existential questions; she also proved an interesting conversation partner for the poet in literary matters because she was so well read—her reading included works by Goethe, Nietzsche, Ibsen, Hauptmann, Kleist, Hölderlin, and Knut Hamsun. In the weeks following their first acquaintance Rilke noted: "Then I was in the lily atelier. Tea was awaiting me. A fine, rich fellowship in conversation and silence. It turned into a wonderful evening; what we talked about: Tolstoy, death, . . . life and beauty in all experience, being able to die and wishing to die, eternity, and why we feel related to the eternal." Shortly after this encounter, on September 12, 1900, Paula and Otto Modersohn became

5a *Portrait of Rainer Maria Rilke*, 1906, cardboard, private collection

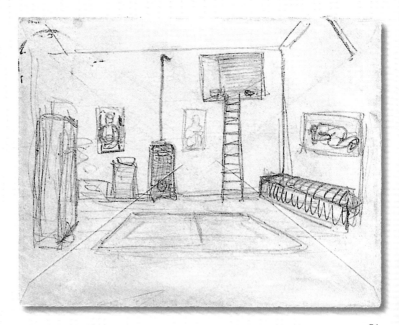

5 b

engaged. *Rilke, who had first thought of moving to Worpswede, decided to stay in Berlin, and in 1901 married the sculptor Clara Westhoff.*

After Paula's temporary separation from her husband, Rilke was a crucial support for her in Paris. They ate out together, visited the Louvre, and met for portrait sittings in the period between May 13 and June 2, 1906, for Modersohn-Becker was painting a portrait of the poet. But Rilke broke off the sittings when Otto Modersohn arrived, having followed his wife. He left Paris in July, and never saw Paula Modersohn-Becker again. The portrait, long mistakenly thought to be unfinished, has since been considered to be one of the most important Rilke portraits.

5b Paula Modersohn-Becker's sketch of her last Paris atelier, 49, Boulevard Montparnasse, on the back of an envelope. On the walls can be seen, from left to right: *Portrait of Lee Hoetger Against Floral Background*, *Woman with Cat and Parrot*, *Reclining Mother and Child II*, 1906, Paula Modersohn-Becker-Stiftung, Bremen

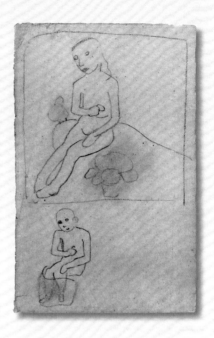

6

6

Depictions of children in paintings and sketches play a central role in the artist's work. Along with the practical consideration that children—especially little girls—were uncomplicated and readily accessible models, there is a further explanation. The painter did not look for what was sweet, cute, and open in children's faces. She found there the unsullied, unadorned truth—as in the faces of old people from the poorhouse scarred by life or of peasants, whom she also frequently portrayed. But she was first met with incomprehension with pictures of this sort: Otto Modersohn noted in his diary on 26 September 1903: "She hates the conventional and is now making the mistake of preferring to make everything angular, ugly, strange and wooden. The color is splendid – but the form? The expression! Hands like spoons, noses like flasks, mouths like wounds, expressions like cretins. She is taking on too much."

6 *Nude Girl Seated on a Hill*, below it *Seated Nude Girl*, 1906/07,
charcoal, Sketchbook XX/8, Kunsthalle Bremen – Kupferstichkabinett –
Der Kunstverein in Bremen

SOURCES

—
TEXT EXCERPTS HAVE BEEN
TAKEN FROM THE FOLLOWING
PUBLICATIONS:

Paula Modersohn-Becker in Briefen und
Tagebüchern, ed. Günter Busch and
Liselotte Reinken, Frankfurt am Main 1979:
58, 60/61, 61/62
Friederike Daugelat, Rainer Maria Rilke und
das Ehepaar Modersohn, Frankfurt am Main
2004: 67
"Paula Modersohn," in: Junge Kunst, vol. 2,
Leipzig 1920: 63–66

Published by
Hirmer Verlag GmbH
Bayerstraße 57–59
80335 Munich
Germany

Cover illustration: *Self-Portrait with Two Flowers
in Her Raised Left Hand* (detail), 1907, see page 41
Double page 2/3: *Moor Canal* (detail), ca. 1900,
see page 13
Double page 4/5: *Still Life with Apples and
Bananas* (detail), ca. 1905, see page 24

© 2020 Hirmer Verlag GmbH, the author

www.hirmerpublishers.com

TRANSLATION
Russell Stockman, Quechee, USA

COPY-EDITING/PROOFREADING
Jane Michael, Munich

PROJECT MANAGEMENT
Rainer Arnold

DESIGN/TYPESETTING
Rainald Schwarz, Munich

PRE-PRESS/REPRO
Reproline mediateam GmbH, Munich

PRINTING/BINDING
Passavia Druckservice GmbH & Co. KG, Passau

Bibliographic information published by the
Deutsche Nationalbibliothek
The Deutsche Nationalbibliothek lists this
publication in the Deutsche Nationalbibliografie;
detailed bibliographic data are available on the
Internet at http://dnb.dnb.de.

ISBN 978-3-7774-3489-6

Printed in Germany

THE GREAT MASTERS OF ART SERIES

ALREADY PUBLISHED